背對哈瓦那　　陳綺貞

Back　　　　 by
towards　　　 Cheer
Havana　　　 Chen

TONE 29

在大海般的時間裡──記陳綺貞「背對哈瓦那」攝影展

Time like an Ocean–Havana at Your Back by Cheer Chen

文：張惠菁

Written by Hui Ching Chang

陳綺貞說：在哈瓦那，時間像海一樣。

Cheer Chen says that in Havana, time is like an ocean.

在哈瓦那，時間緩慢停滯。人生選項有限，沒有急著要去的下一站。家家把街道當作客廳，電視機與收音機都開到最大聲，於是城市籠罩在聲音裏。說話聽不見，得用手勢切穿噪音（因此陳綺貞說：「手是聲音的表情」）。

In Havana, time flows slowly. There aren't many choices in life, no next destination to hurry to. Every household extends their living rooms further out to the streets, turning their TVs and radios as loud as could be, thus bombarding the city in various sounds. Human voices are not heard amongst such noises; hand gestures are the sound of expression.

「背對哈瓦那」不只是個旅遊照片展。陳綺貞以五個主題系列，探索時間的概念，與哈瓦那如大海般的時間細細說話。

Havana at Your Back is more than just an exhibition of travel photos. Through five sets of photos categorised by themes, Cheer Chen explores the concept of time through a conversation with it.

在 Hand 和 The Story of Street 系列，你會看到她拍哈瓦那人的臉，手，街頭角落等等。手的姿態、紋路，手機汽車等產品在街景中的缺席，也都是時間的一種面目。她拍的事物小，時間大；事物局部入鏡，時間全面籠罩。

In the first two sets, "Hands" and "The Story of Street", you will see the faces and hands of the people of Havana in the corners of streets through her camera. You will see the gestures and textures of their hands, street scenes without any presence of products like mobile phones and cars; all these are dimensions of time. She has captured small glimpses of things but covered a wide range of time; her

photos have recorded only parts of what she saw, but they show the completeness of time.

Face 系列中的臉孔，陳綺貞大多只用傻瓜相機即抓即拍，往往也只拍一張，就是一眼看到的印象。作為一個旅行者，她的鏡頭無法深究他們真正是誰，有過什麼故事，也無意介入。這些哈瓦那人短暫出現眼前，她看到什麼，就是什麼。於是這些臉孔成了哈瓦那城市與陳綺貞個人生命之間一觸即過的吉光片羽，時間的碎片。

In "Face", the snaps are her first impressions of people taken right at the moment. Mostly they are only one shot of the scene by her camera. As a traveller, she had no way to investigate her subjects in great depth: who they really were, and what they had done. Yet she never intended to intrude. These people appeared temporarily in front of her, they were whatever they were in her eyes. Consequently, these faces have become fragments of time, the flashes of the photographer's time spent in the city of Havana.

但也只有碎片具備切穿整體的力量。在老人院的系列照中，老人原本都在發呆，木木然不動。綺貞用拍立得給其中一位拍了照，把老人給激活了：「It's Magic!」一個又一個老人過來讓她拍照，發出笑聲、叫聲，整座老人院醒了過來。最後一張開懷大笑的合照，實際上是「魔法後」的老人院。確實是魔法，因為時間被驅動了，轉速突破事物凝止的表面。

Yet only fragments are equipped with the power to penetrate what is complete. In the series featuring a nursing home, in the beginning the senior citizens were inanimate and unresponsive. Then one of them got awoken by Cheer Chen's Polaroid shot. "It's magic!" One by one they all came around for snaps, laughing, whooping, awakening everyone. The very last group photo of joy and laughter is actually that of the nursing home "under a magic spell." It was indeed a magic spell, by its power time was re-initiated, and the still surface of things broken.

到了 The Story of Rain 系列，陳綺貞忽然翻轉角色，讓自己進入時間。驟雨傾盆，匆忙跳上計程車……，一系列從她視角半格連拍的畫面——攝影者有意揭露她的位置，其實也在時間之流中。這時間顯然與臉、手系列的時間有別。匆忙，有動作，有目的地，因一場大雨而加速，是旅人從外界帶入的時間感。

In the set called "The Story of Rain", Cheer Chen suddenly reverses the role and enters time. Hopping into a cab in the pouring rain all of a sudden... a series of half-frame rapid shots—the photographer intentionally reveals where she is, still in the stream of time, in fact. The time here is obviously different from that in the first two sets of her photos. Being in a rush, being in action, having a destination, getting accelerated by rain are all senses of time brought in to focus by a traveller.

整個哈瓦那與外界時間的界線在海邊。哈瓦那靠海，面向大海而坐，就是背對哈瓦那。在這些海景的攝影裡，或許是陳綺貞向她所喜愛的藝術家杉本博司致意。不過，不同於杉本博司那種中性、寧靜到無機的海洋，當陳綺貞寫下「背對哈瓦那」這個命名，海

便從此攜帶著邊界的寓意而有了故事。一個年輕的遠望者，與大海、大海般的時間之間，不對等、無止盡的面對。海平面與男孩身體的輪廓，一條其實不曾觸及的切線。

Havana has the ocean as its borderline that separates it from time outside. Sitting there facing the ocean, you will have Havana at your back. These photos of the ocean scenes may be Cheer Chen's tribute to Hiroshi Sugimoto, an artist she admires. However, unlike this artist's neutral, serene ocean, Cheer Chen faces an ocean that carries a story because it borders Havana. A young spectator, the ocean, and the time which is like an ocean, confront one another unequally and infinitely. The surface of the ocean, and the silhouette of the boy's body. It seems like a line that cuts through, but it in fact touches neither subject.

陳綺貞是歌手，是個經常在演唱會那被聲音與光高度差異化的時間裡，面對自己與觀眾的人。從這個角度去看綺貞這一系列在哈瓦那與時間的練習，感受很不同。「如果不能從平凡的事物裡得到什麼，那就必須自己去創造一些特別的東西。」她提到馬奎斯的《百年孤寂》：「世界還太新，許多事物還沒有名字，必須用手去指。」在養老院，老人們看到拍立得時驚訝的表情，就像是《百年孤寂》裡的馬康多人第一次摸到冰塊，或是綺貞第一次發現自己寫了一首歌，第一次在台上感覺和所有人連繫在一起般的完整……。

Cheer Chen is a recording artist, who often faces herself and an audience in concerts where the sense of time is distorted owing to sound and light. It gives a different feeling to appreciate her exercise with time in Havana from this angle. "If one can not draw something out of the plain everyday things, then one has to create something special by self." She quotes from Márquez Gabriel García's One Hundred Years of Solitude, "The world was so recent that many things lacked names, and in order to indicate them it was necessary to point." In the nursing home, the surprise shown in the faces of those senior citizens are exactly like those people of Macondo in One Hundred Years of Solitude who touch ice for the first time, or like the first time Cheer Chen composed a song, or the first feeling of connection she felt with the crowd in her concert...

在這大海般無盡又轉瞬變化的時間裡，陳綺貞提起她小時候問過媽媽的一個問題：「剛才的我到哪裡去了？」這疑問像個氣泡，突破了時間海洋的表面。卻又轉瞬即逝。在我們背對的海岸上留下了記憶。

In the time that's like an ocean with its changeable nature, Cheer mentioned a question she asked her mother when she was little, "Where has the me of then just gone?" This query was like a bubble, which broke through the surface of the ocean. Yet it also disappeared in an instant. It exists as a memory on the coastline at our back.

本文為2012背對哈瓦那亞洲慈善攝影展介紹文

This is an introduction of the "Havana at Your Back" photo exhibition held in 2012.

背對哈瓦那

Back towards Havana

文：陳綺貞

by Cheer Chen

從看見，聽見，面對，到背對。

From seeing, hearing, facing, to turning back towards.

到了哈瓦那，看見無數手的語言，這是充滿聲音的城市，傾盆大雨，家家戶戶的電視，廣播，修了再修的老爺車引擎，手勢飛出聲音的屏障，才能傳達更多精確心意。在一個沒有臉書，也無法上網的城市，我得以直接和他們的臉對話。純樸的熱帶居民，於鏡頭十分信任，按快門時不得不對「捕捉」畫面的心態省思。

I saw countless expressions of hands in Havana. This is a city of voices, the pouring rain, the TV and radio from behind each house's doors, the raging engines of old cars that had undergone numerous repairs. Hand gestures flied over barriers of noises, to convey more precise feelings for each other. In a city with neither Facebook nor internet, I got to converse directly to their faces. Simple and pure tropical residents trusted cameras without holding back, I couldn't help introspect my own thoughts when I "capture" these images.

清晨五點，男孩獨自面海，我從看見他，變成他，試想他看的，和他背對著的。

5 o'clock in the morning, the boy sat there facing the sea alone. From seeing him, I became him, imagining what he saw, and what he had turned his back towards.

攝影從在場證明，慢慢退回成一種思索，這本冊子記錄了這個過程。

From a proof of presence, photography has stepped back slowly, to become a way of thinking. This book has recorded the process.

背對哈瓦那

Back
towards
Havana

Rolleiflex 2.8F

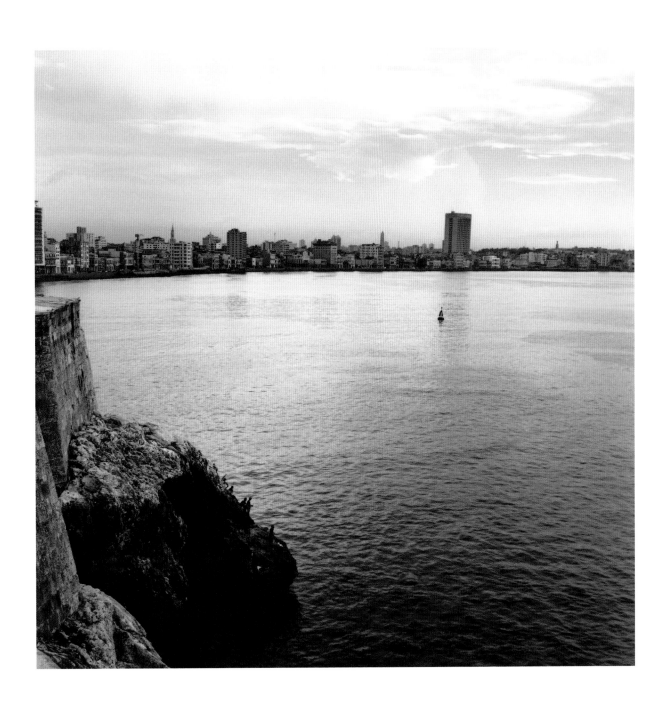

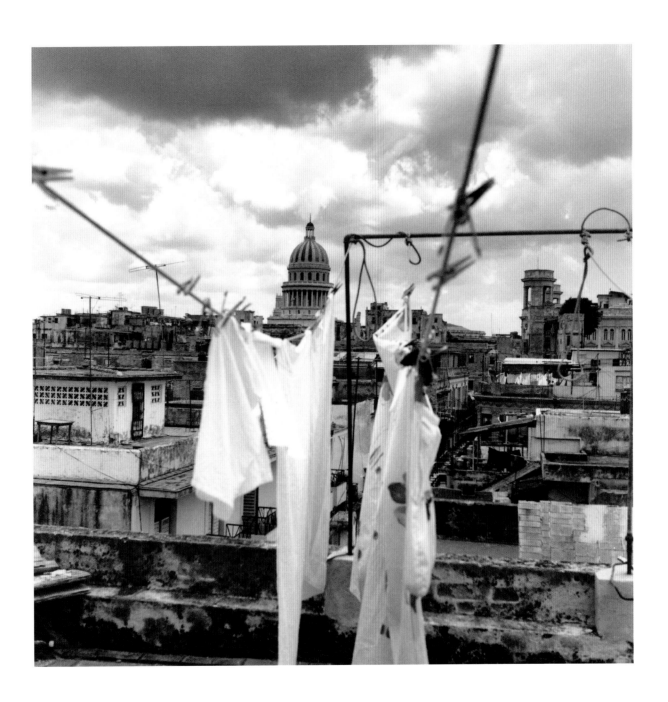

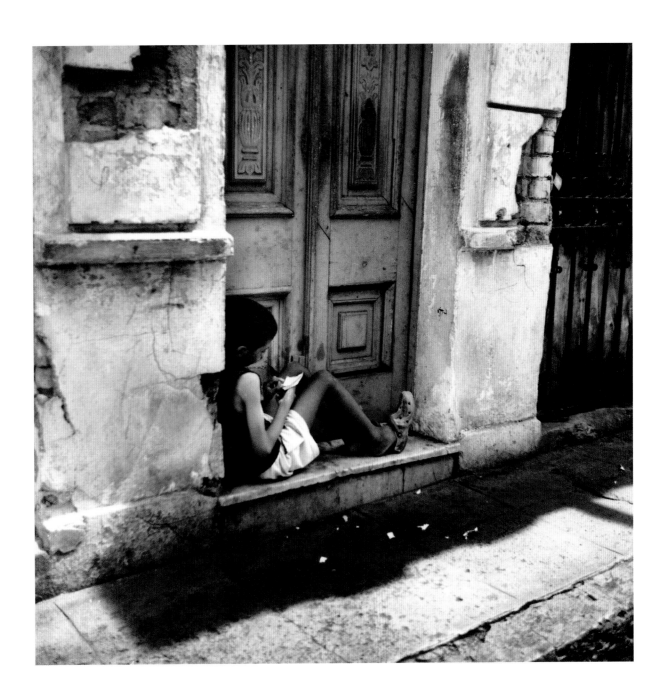

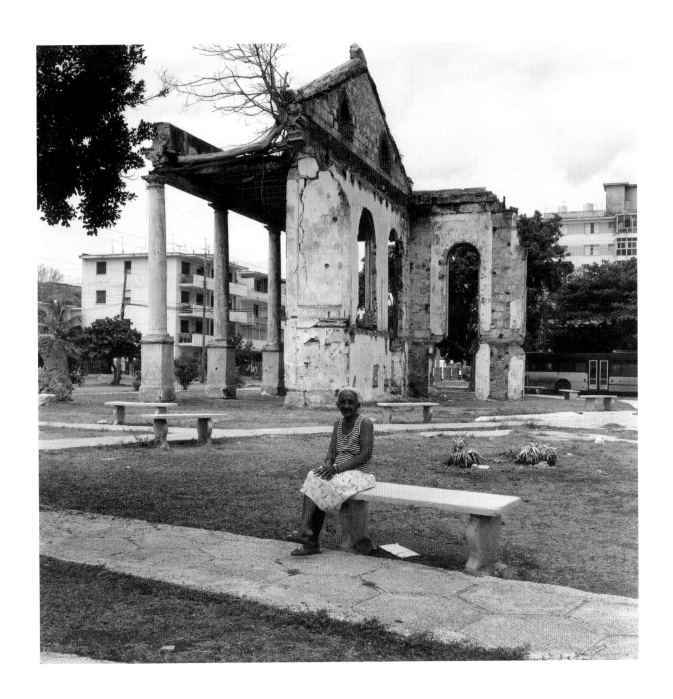

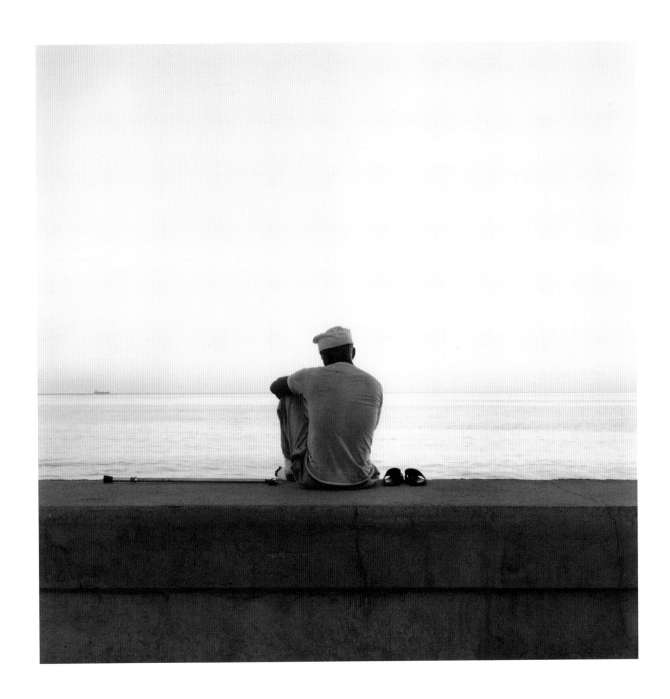

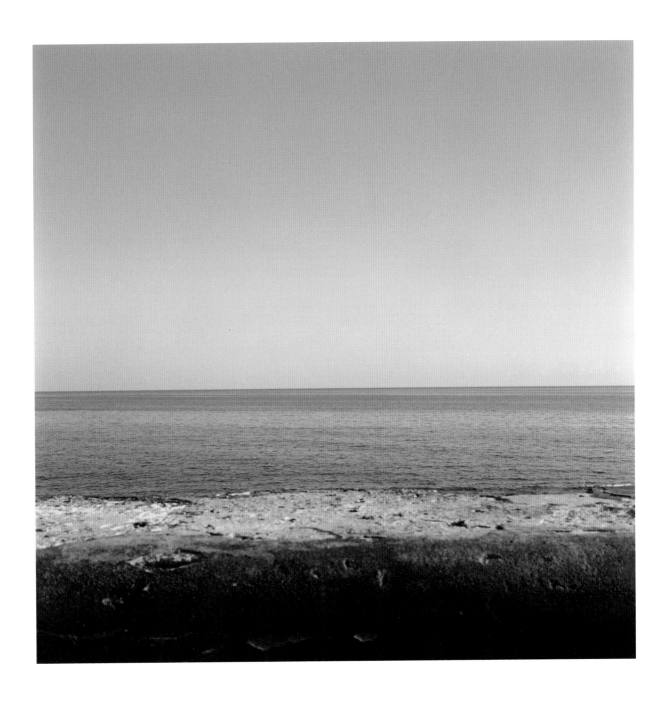

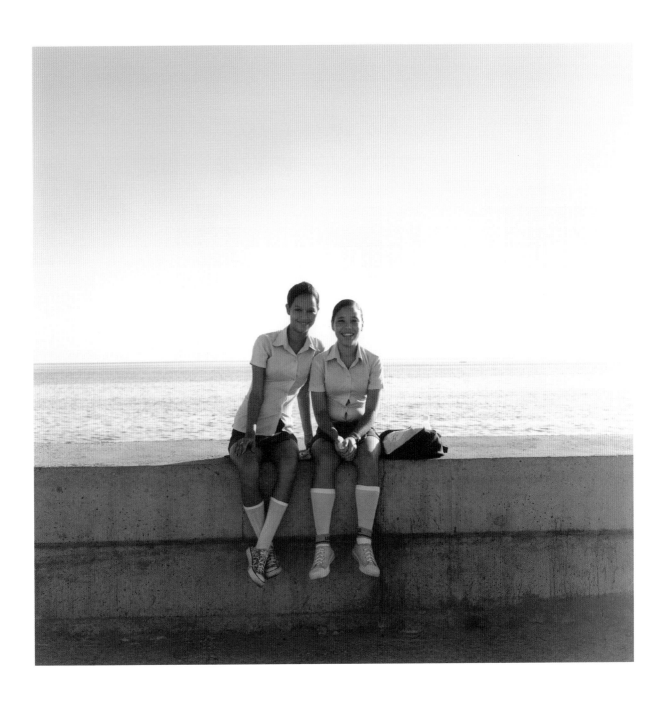

HORIZON PERTEKT

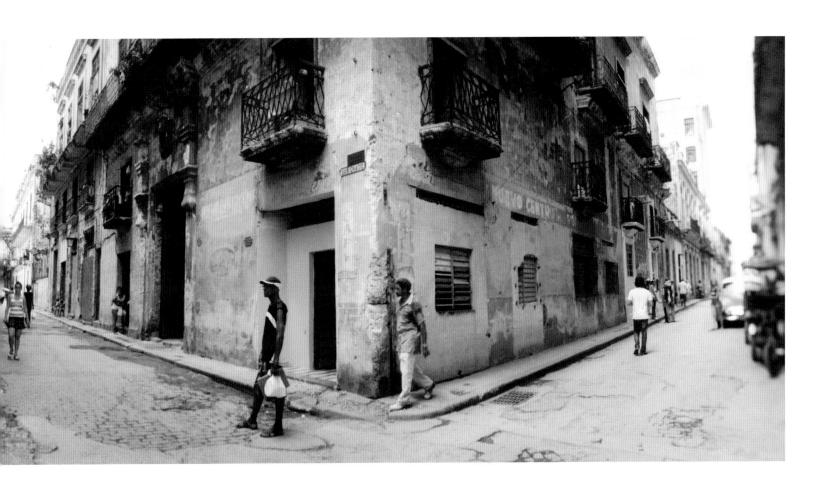

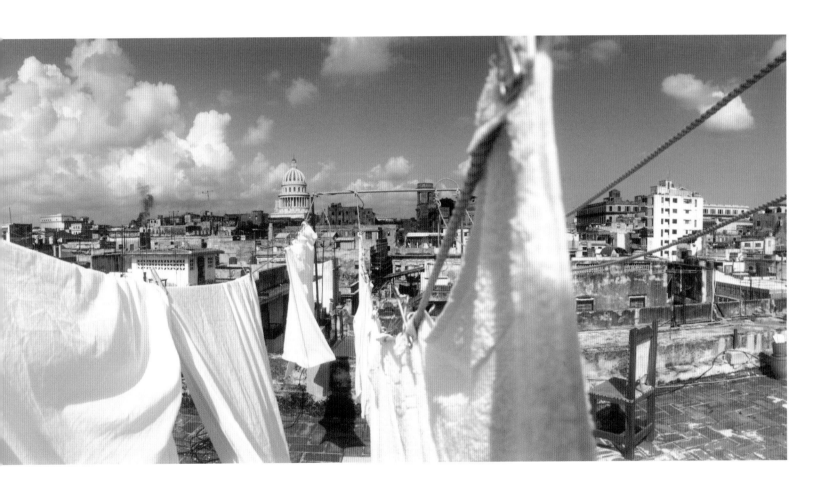

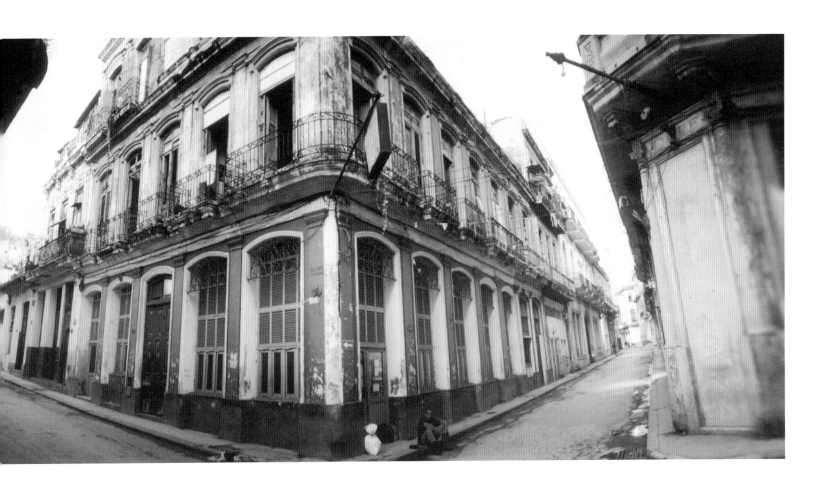

Olympus PEN F

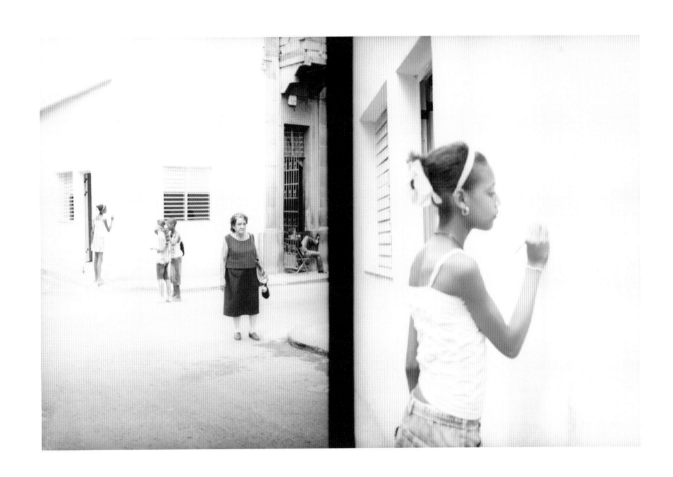

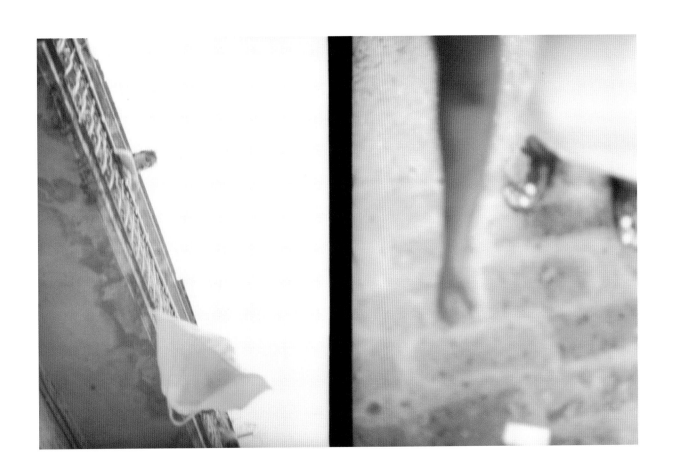

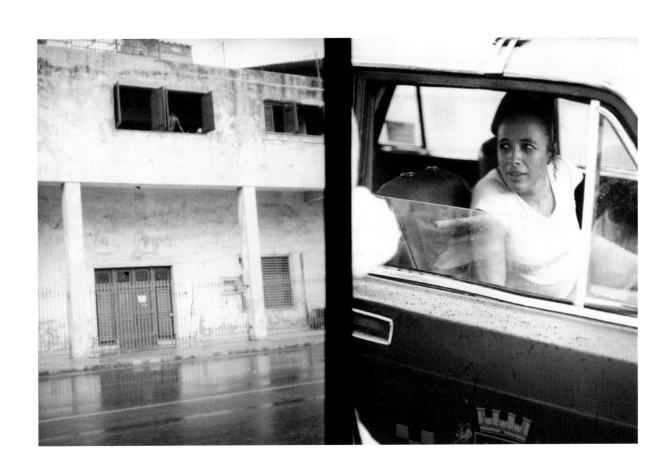

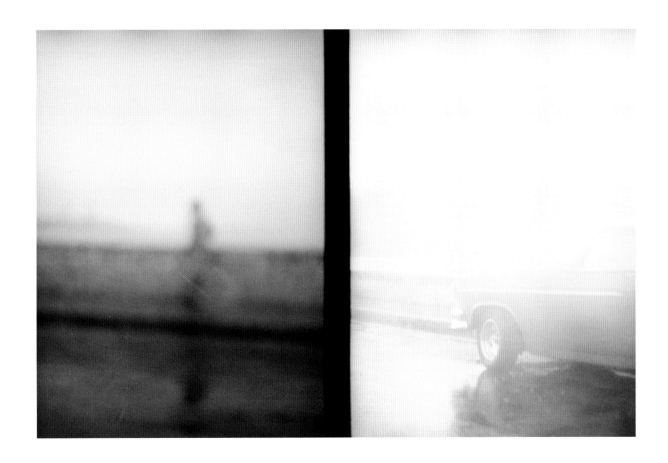

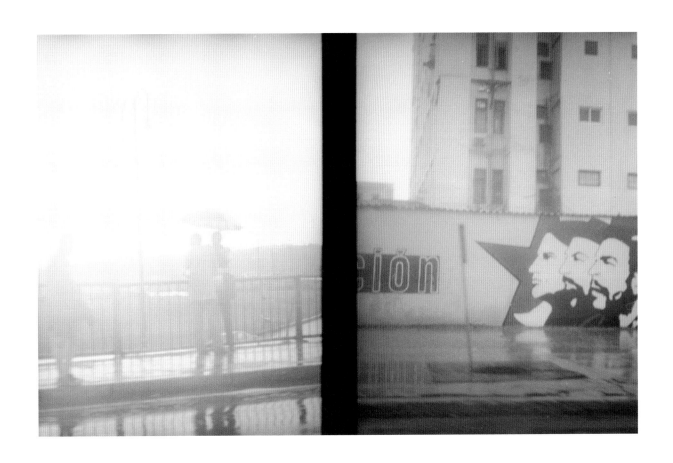

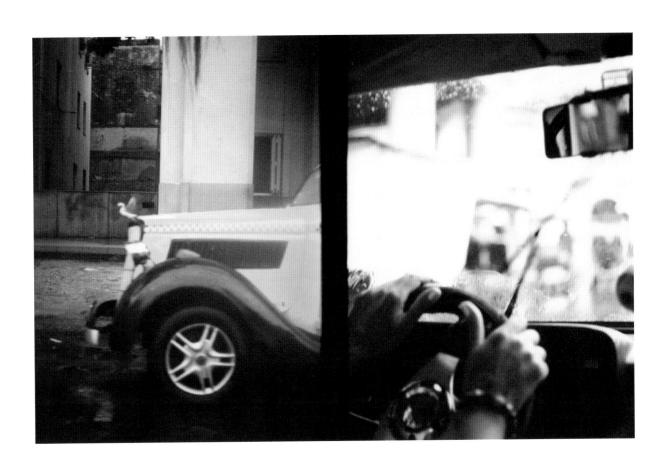

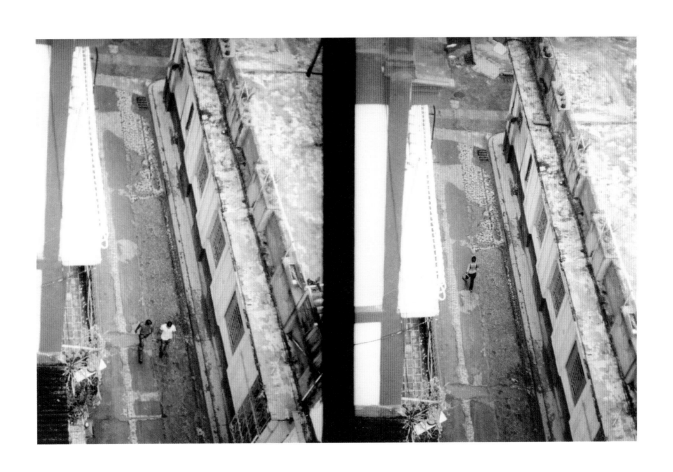

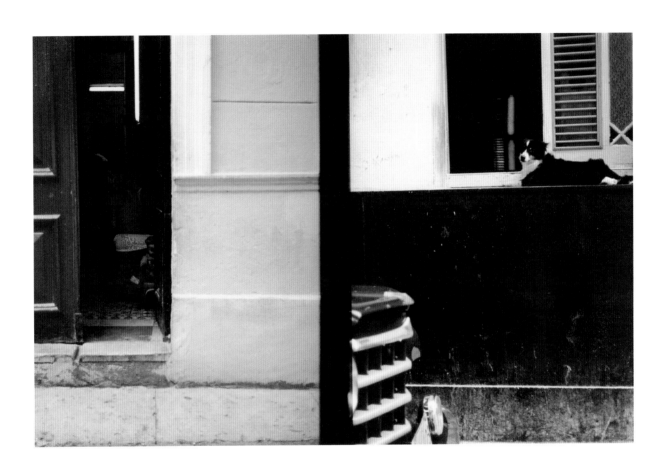

Nikon FM2

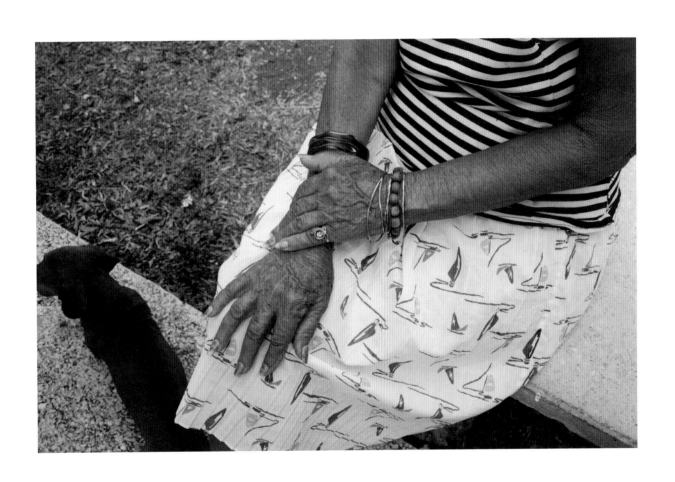

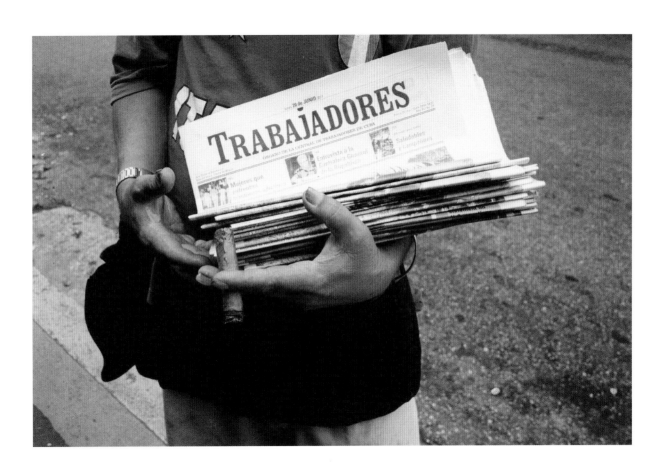

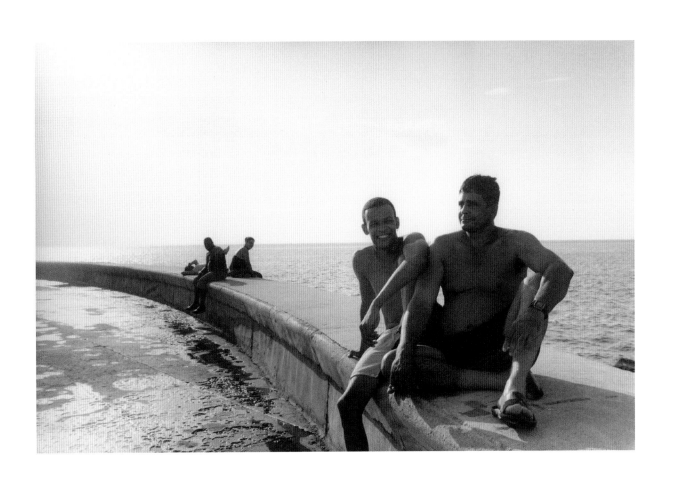

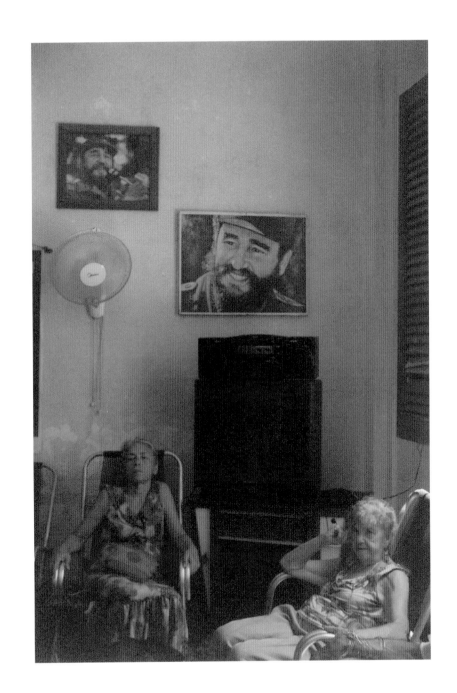

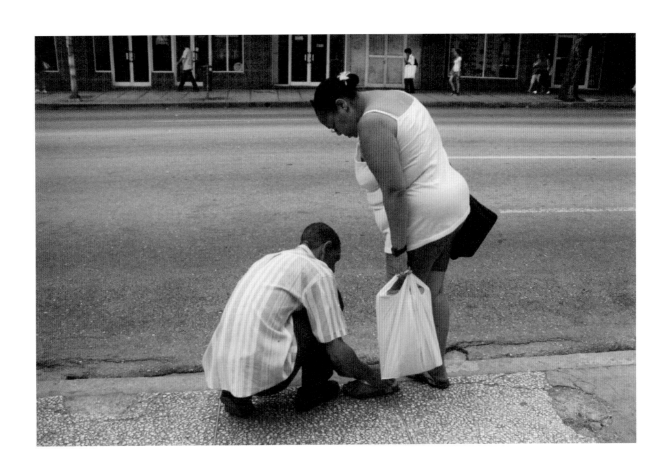

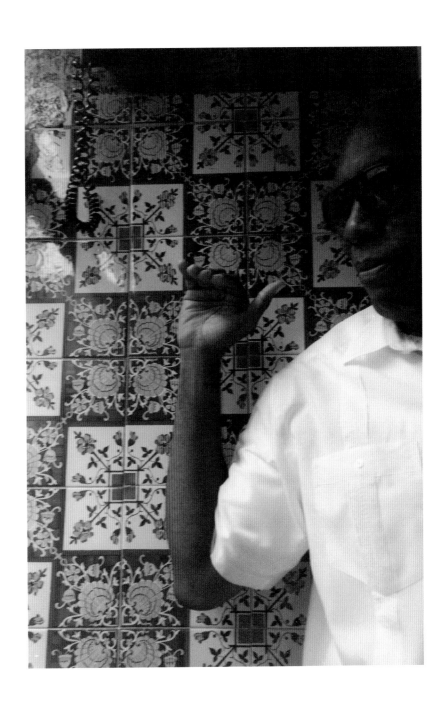

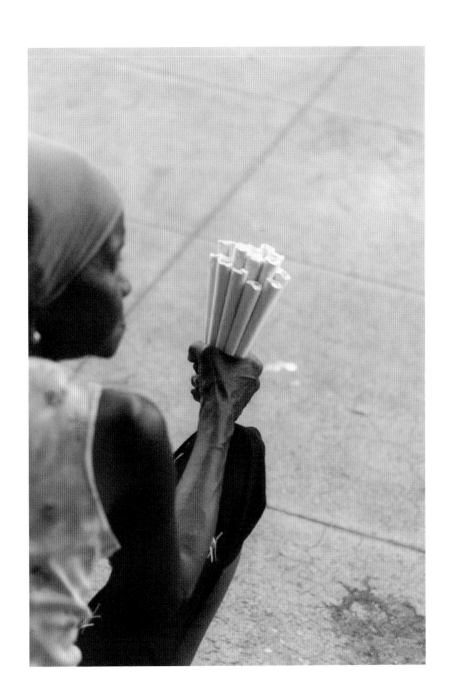

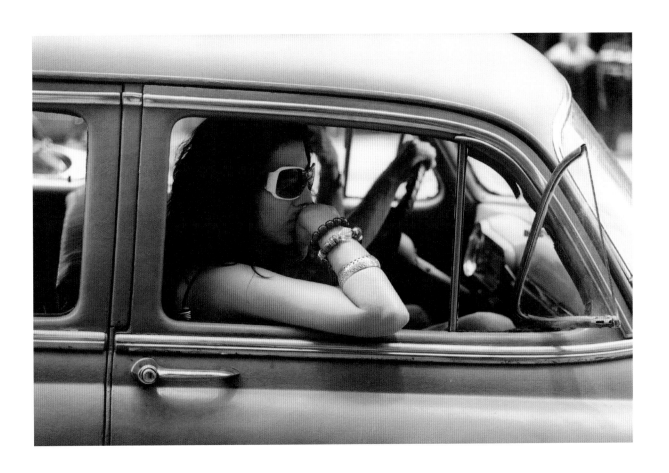

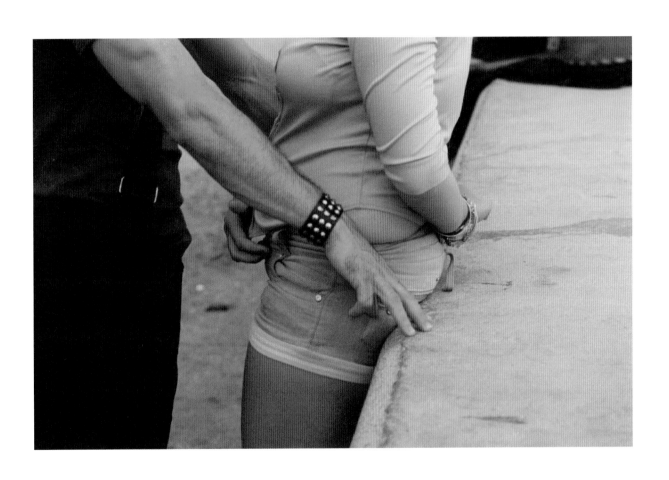

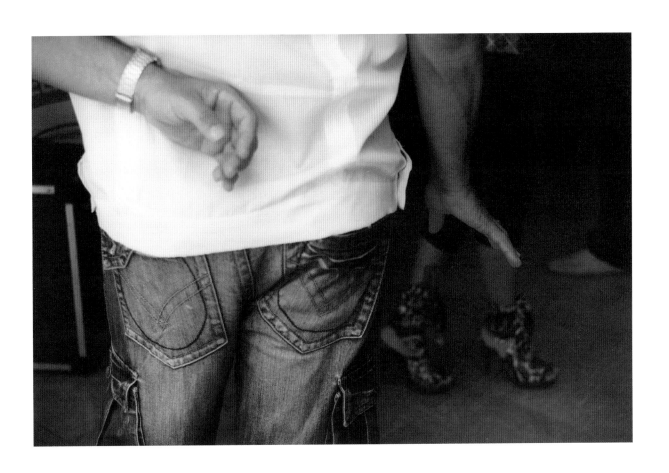

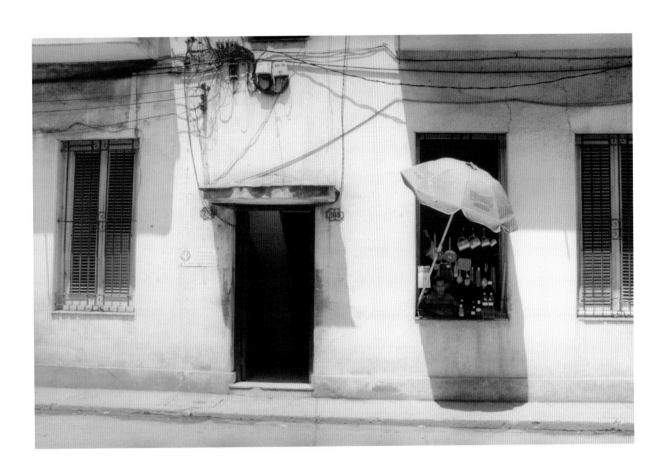

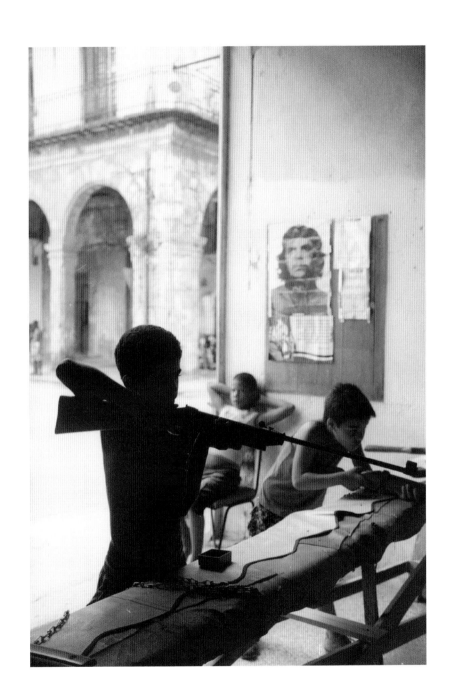

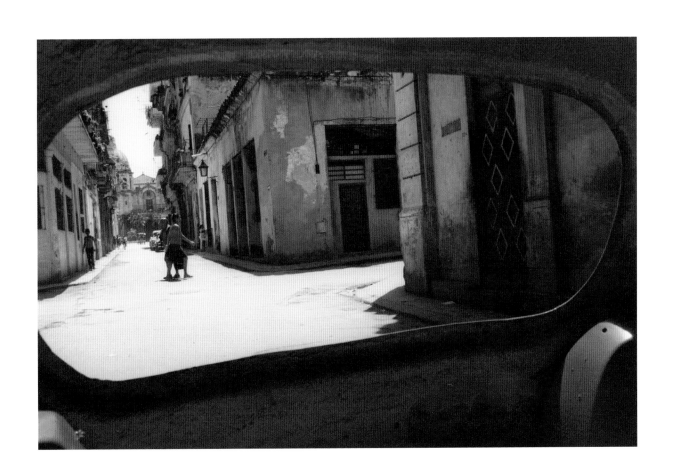

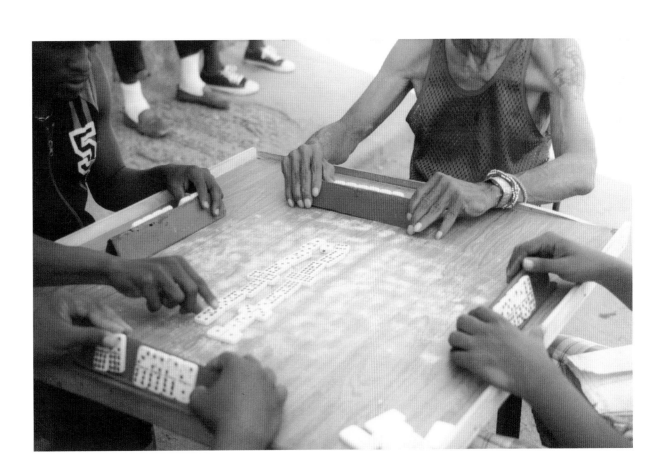

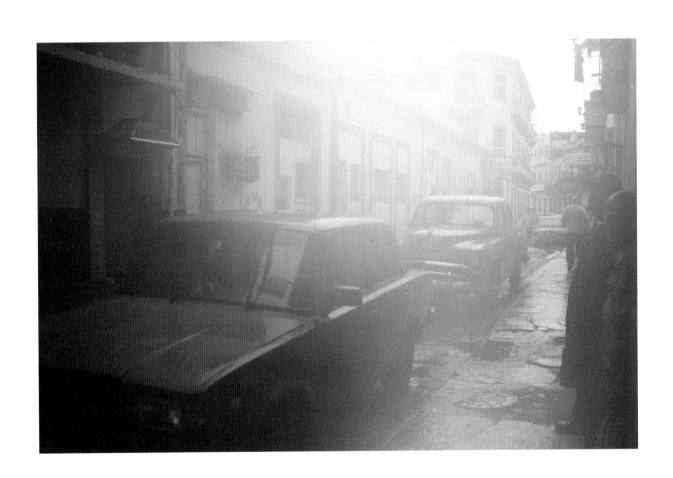

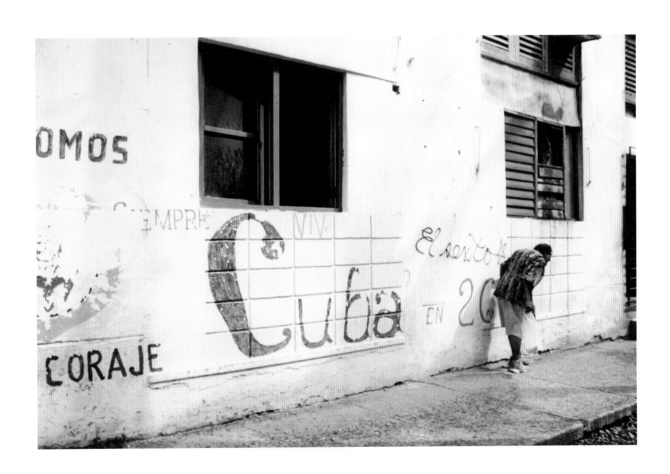

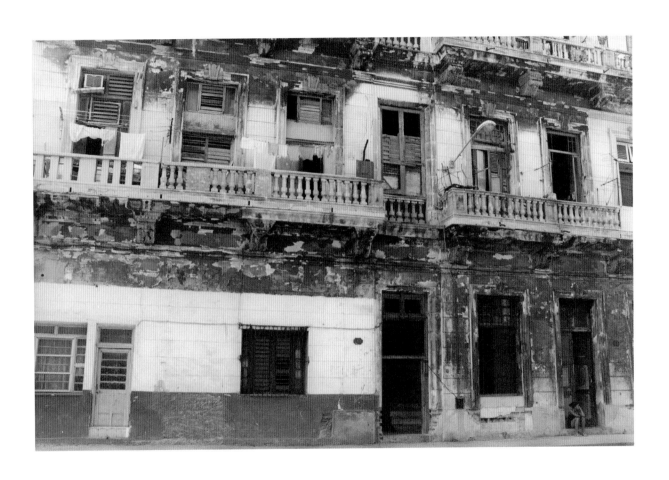

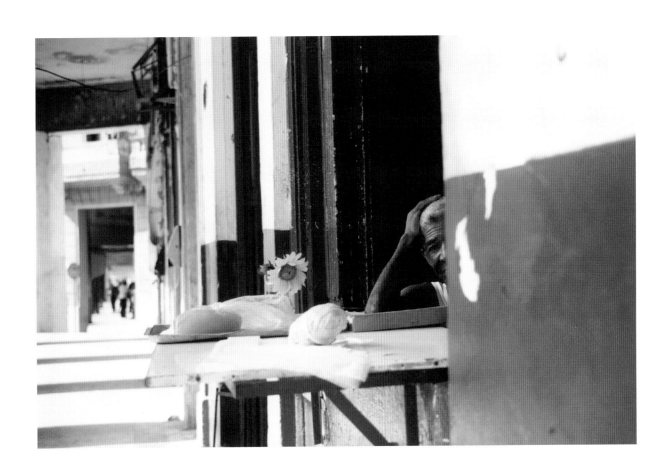

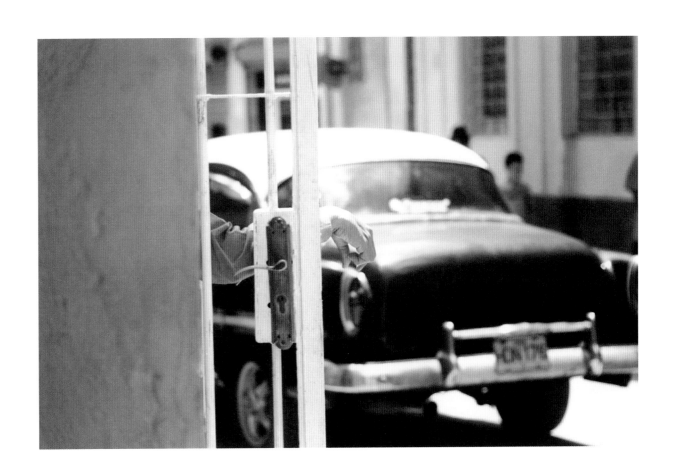

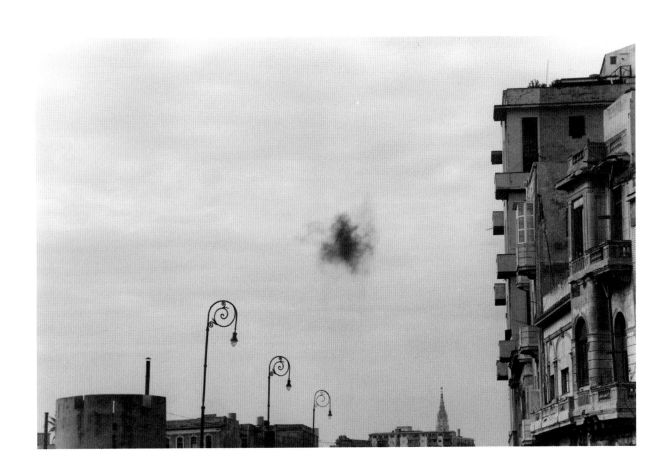

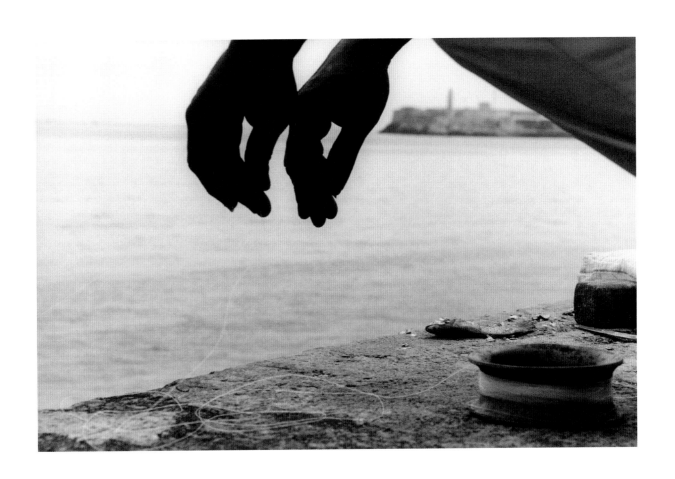

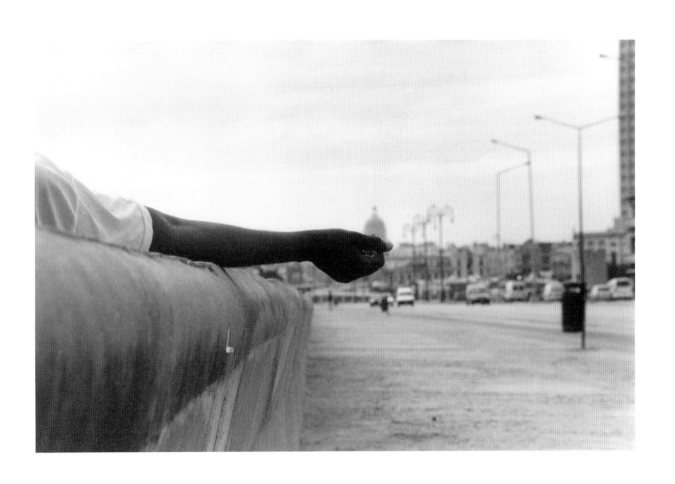

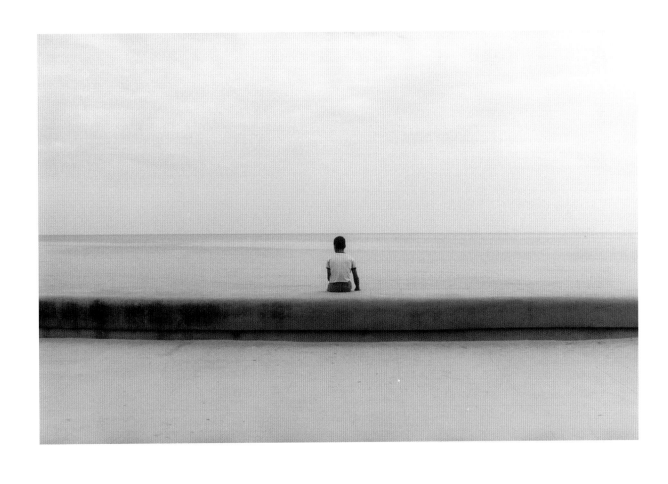

背對哈瓦那／陳綺貞作·
——初版·——臺北市：大塊文化，2015.11
面； 公分·——ISBN 978-986-213-640-9（精裝）

1.攝影集

958.33 104019012

TONE 29

背對哈瓦那
Back towards Havana

作者、攝影：陳綺貞
Author, Photographer: Cheer Chen

經紀公司：添翼創越工作室
Management Company: TEAMEAR MUSIC

拍攝協力：添翼文創事業有限公司
Film Executor: TEAM CREATIVE

責任編輯：鍾宜君
Editor: Renee Chunng

平面設計：王志弘工作室
Graphic Design: wangzhihong.com

企劃執行：陳悅綺
Marketing Executor: Yueh-Chi Chen

製作協力：莊雅婷
Project Integrator: Ya-Ting Chuang

底片沖洗：陳豐毅、達蓋爾銀鹽暗房工作室
Film Processes: Max Chen, Daguerre Lab

底片掃瞄：潤石數位分色
Scan: Round Stone Digital Process CO.,Ltd

翻譯：林婉瑜
Translator: Wan-Yu Lin

特別感謝：張惠菁、柯錫杰、郭英聲
Special thanks: Hui-Ching Chang,
Xi-Jay-Ko, Ying-Sheng Quo

出版者：大塊文化出版股份有限公司
台北市105南京東路四段25號11樓
Tel：02-8712-3898　Fax：02-8712-3897
www.locuspublishing.com
E-mail：locus@locuspublishing.com
讀者服務專線：0800-006-689
出法律顧問：全理法律事務所董安丹律師
郵撥帳號：1895-5675
戶名：大塊文化出版股份有限公司

總經銷：大和書報圖書股份有限公司
地址：新北市新莊區五工五路2號
Tel：02-8990-2588（代表號）　Fax：02-2290-1658

製版：瑞豐實業股份有限公司
初版一刷：2015年11月

ISBN：978-986-213-640-9
定價：新台幣 1,500 元整